ENABLING
SOLUTIONS

ENABLING SOLUTIONS

for SUSTAINABLE LIVING

A Workshop

UNIVERSITY OF
CALGARY
PRESS

Contributing Editors: Ezio Manzini, Stuart Walker, and Barry Wylant

University of Calgary Press
2500 University Drive NW
Calgary, Alberta
Canada T2N 1N4
www.uofcpress.com

LIBRARY AND ARCHIVES CANADA
CATALOGUING IN PUBLICATION

Enabling solutions for sustainable living : a workshop /
edited by Ezio Manzini, Stuart Walker and Barry Wylant.

Accompanied by a DVD.
Includes bibliographical references.
ISBN 978-1-55238-236-3

1. Suburbs–Environmental aspects. 2. Sustainable living.
3. Suburban life. 4. City planning–Environmental aspects.
I. Manzini, Ezio II. Walker, Stuart, 1955- III. Wylant,
Barry, 1962-

HC79.E5E63 2008 307.1'214 C2008-900761-1

The University of Calgary Press acknowledges the
support of the Alberta Foundation for the Arts for our
publications. We acknowledge the financial support of
the Government of Canada through the Book Publishing
Industry Development Program (BPIDP) for our publishing
activities. We acknowledge the financial support of the
Canada Council for the Arts for our publishing program.

Printed and bound in Canada by Transcontinental Printing
∞ This book is printed on 55 lb. Enviro 100 paper

Cover design, page design and typesetting by Melina Cusano

The contributing editors would like to thank the University
of Calgary for its support of this project.

TABLE OF CONTENTS

FOREWORD

Most of the enviromental impact of the products, services and infrastructures that surround us is determined at the design stage – not at the point of purchase, and not at the point of use. The ways we have designed the world force most people to waste stupendous quantities of matter and energy in their daily lives. There's a tremendous opportunity here to re-design the structures, institutions, and processes that shape the ways we live.

Many of the elements of a sustainable world already exist. Some of these elements are technological solutions. Some are to be found in the natural world, thanks to millions of years of natural evolution. The majority of solutions are social practices – some of them very old ones that have evolved in other societies and in other times. From this insight flows the proposition that designers should become hunter-gatherers of models, processes, and ways of living that may already exist. Rather than design new services and systems from scratch, we need to ask: Who has cracked a similar question in the past? How might we learn from, adapt, and piggyback on their success?

If the focus of design evolves from pure invention to selection, a key question arises: How are we to choose among the myriad potential solutions that are to be found out there? The concept of *enabling solutions* is absolutely key here – both as a filter and as an inspiration. The concept provides a vision of where we want to be, which drives strategy. The prospect of *enabling solutions* entails the re-assertion of human agency in our systems-filled world. A future shaped by human agency provides the meaning and therefore motivation that are needed if diverse people are to collaborate and bring it about.

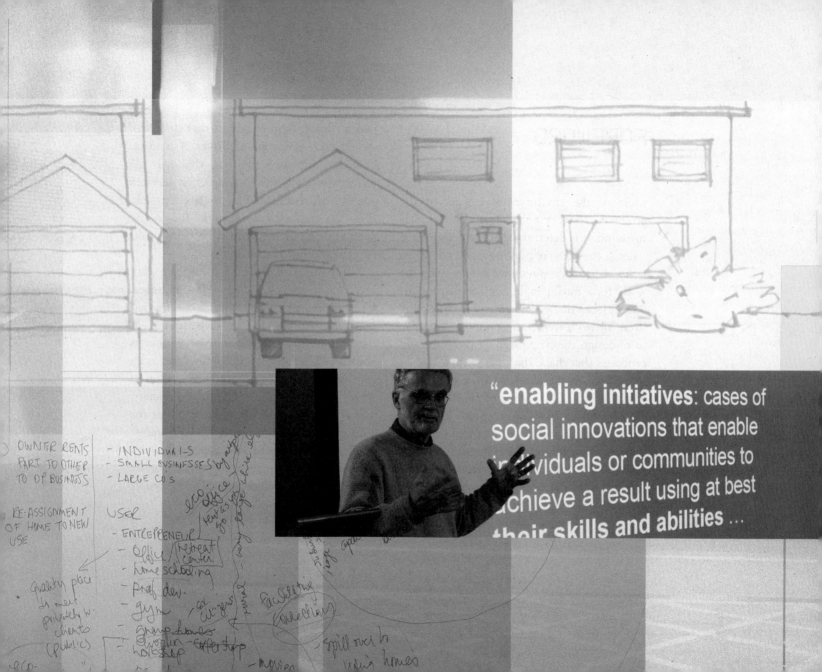

INTRODUCTION: DESIGNING FOR SUSTAINABILITY AND STRATEGIC DESIGN

Ezio Manzini

DESIGN IN A LIMITED, COMPLEX, FLUID WORLD

Transformations occurring on a worldwide scale challenge the cultural background and the activity of industrial design (as they do those of any profession). In this shifting reality, the world of industrial design, meaning the community of practitioners interested in product design for mass production, must redesign itself. This is primarily because the object of industrial activity, that is, the very object of design projects, is and has been changing. (This is the notion of "product" as a product system and as an artefact network, a notion which constantly varies according to specific user and context characteristics.) Further, due to the increasing degree of connectivity in socio-technical systems, and changes in methods, timing, and actors, the roles of design processes are also changing rapidly. (This refers to the constant interaction between designers and users of project-orientated partnerships and, in the end, of distributed design activities.)

Design was born and has developed its conceptual and operational tools in a world that looked simple, solid, and limitless. This triad of concepts has been swept away by the force of new phenomena: by the discovery of system complexity, by the need to learn how to navigate in the fluidity of events, and, today, with reference to the transition towards sustainability, by the emergence of limits. It is in this new complex, fluid, limited world that design must operate today. And it is in this complex, fluid, limited world that design for sustainability has to find its way and to define its concepts and tools.

STRATEGIC DESIGN FOR SUSTAINABILITY

With the expression *Design for Sustainability* (*DfS*) we usually mean a design activity that aims to encourage *radical innovation* orientated towards sustainability, i.e., that steers the development of socio-technical systems towards low material and energy use and high regenerative potential. Effectively, to move in this direction, we need to use a *strategic design* approach (and strategic design tools). Thus, in order to arrive at design for sustainability, intended as *strategic design for sustainability*, it is necessary to work through strategic design and its characteristics, aims, and ways of operating.

This is not the appropriate place to enter into the merits of all the different forms that strategic design may take. Suffice it to say that they have in common planning activities whose project objective is a system, consisting of products, services, and communication, defined overall as a *product system*. This definition includes widely differing activities, ranging from those used to define the *identity* of a product line and/or business service (including that of an entire company), to those relating to the *re-shaping of a company's activities* (e.g., the re-orientation of a previously *product-orientated* company towards the delivery of services and the innovative use of the Internet to define new forms of relationship with clients and/or suppliers), to those which lead to *offering solutions* and, for this reason, attempt to bring together the various actors necessary to achieve the desired result.

Design for sustainability may occur in any of these areas, but it has one particular characteristic: the product system as it is applied must relate to an *orientated radical innovation*, i.e., it must encourage, facilitate, and be part of a process of systematic change. This implies a break in continuity with the initial situation and an outcome consistent

with the fundamental criteria for sustainability.

This definition of the field of activity necessary for sustainable design brings with it significant implications: it is unlikely that the radical innovation we are referring to can be traced back to a purely technical dimension. It always requires consideration of a system in its entire social, technological, and natural complexity. In addition, it is unlikely that decisions relating to such a system can be taken by one single actor or protagonist (as we can refer to a single producer and/or manager, when talking about the production of a product or service). In this case the innovation involves a number of different actors (producers, service providers, institutions, and various organizations, whether they are an expression of society in general or of single groups of potential users). Consequently the innovation that interests us here is a social occurrence, or rather, the social dimension of the desired phenomenon is greater than

normally considered when referring to innovation and design.

DISTRIBUTED DESIGN CAPACITIES

When talking about design for sustainability we are referring to designers who operate on complex socio-technical systems to encourage innovation. Such innovation, in turn, is more social than technological. It rises from the bottom rather than filtering down from the top. It is achieved through the involvement of a multiplicity of actors rather than made in a laboratory or design centre.

Seen in this way, the professional profile of a designer tends to differ from the historically consolidated form we are used to. The classic idea of a designer is of one who, case by case, directs his or her activities to a final user, working for or with a firm. In the new

scenario, the designer should act within a more complex network of actors, which may certainly include private sector firms, but where the main client could be a public institution such as a local authority, or any other social entity.

If, as we often say, the transition towards sustainability is a learning process and can provide the grounds for diffuse creative initiatives (we call these "*creative communities*"), then the designer increasingly assumes the role of *facilitator* in the learning process and acts as a *support* for the distribution of design skills and thinking. In other words, the field of action moves further and further away from the figure of a traditional designer, towards one of an actor operating to *make DfS-oriented events happen*, making sure interested subjects can effectively participate and do so creatively. He becomes a process facilitator who acts with *design tools* to generate ideas on possible solutions, then visualizing them, arguing through them, and placing them

in wide, multi-faceted scenarios, which are presented in concise, visual, and potentially participatory forms.

As we gradually move towards this area of activity, the designer is faced with the question of new skills and new tools, or rather of skills and tools that in principle have always been present in the bag and baggage of strategic design, but which have never appeared particularly important until now.

CO-OPERATIVE PROCESSES, PARTNERSHIPS, AND THE DESIGNER'S ROLE

Strategic design, by definition, deals with complex artefacts. If these artefacts are to be sustainable solutions, this complexity can only increase (since their entire life cycle must be taken into account, along with their relationship to the specific contexts of production

and use). Every solution and especially a sustainable solution, brings a complex set of relationships into play with new forms of collaboration between the various actors involved. These forms of collaboration are not easy. In general, they do not come about spontaneously, but are the result of deliberate action.

In the face of this statement, one of the most important issues in the development of sustainable solutions is precisely that of *co-operation* and *partnership*: how can we bring a multiplicity of actors to focus on one objective? How can we facilitate the generation of shared visions? How can these visions actually come to trigger individual energies?

To answer these questions, designers must put themselves forward as those who can facilitate shared vision-building by generating and proposing possible scenarios and solutions. To play this role, however, designers must have a new generation of conceptual and operational tools at their disposal. Such tools must provide everything they need to conceptualize, visualize, and develop scenarios and sustainable solutions within a framework of co-design that characterizes the innovation of contemporary socio-technical systems.

DESIGN CONTEXT: ENABLING SOLUTIONS FOR SUSTAINABLE URBAN EVERYDAY LIFE

Ezio Manzini

The notion of a sustainable society, and of its possible configuration, may be tackled usefully by adopting different points of view and working methodologies. In this discussion, the daily dimension of our existence serves as a point of reference which has two complementary aspects. It can be understood both as *the world as seen by those who live in it* and as *a socio-technical system*. Moreover, the latter can be influenced through "strategies of bottom-up intervention," i.e., starting from the local environment.[1] The local environment considered here is that of cities; we will focus on *everyday life in urban space*.

EVERYDAY LIFE AND NEW WAYS OF LIVING

The 'everyday' we are talking about can be defined as one's context of daily activity, in other words, everything that limits or offers opportunities in life and everything that absorbs the consequences of an individual's choices and actions. As Laura Balbo, a significant Italian researcher on everyday life, says, "the everyday is not the sense of routine, of what we take for granted, of the unimportant. It is rather the space-time dimension of each social actor who conceives, articulates and realizes strategies, adding inventive moments to adaptive moments." In *contemporary* everyday life, the inventive dimension tends to prevail over the adaptive. This is not because there is widespread creative capacity but because people's living contexts change so quickly that breaking the routine, and consequently having to invent new ways of being and doing, becomes necessary for each one of us.

When we give ourselves the perspective of sustainability, this need to re-invent the everyday increases enormously, and the most elementary functions of daily experience appear as challenges that are not easy

2

to respond to. What might life be like in a sustainable society? What might it be like to take care of the children and the elderly, to work and to study, to maintain the house, to move residences, etc.?

The capacity to imagine something that does not yet exist, and the action strategy for achieving it, is the essence of every forward-looking attitude. Adopting this attitude and putting it into practice is neither obvious nor simple. A more or less resigned acceptance of the existing, an escape towards dreams and unrealizable utopias and, not least, the burden of defining and enacting action strategies, all tend to hinder this attitude. This makes a forward-looking "design" capacity a rare resource and one to be cultivated. It is a social resource that looks even more precious when faced with the enormity of the problems at play and the changes that ought to take place. Indeed, it would appear to be indispensable for the activation of any non-catastrophic process of transition towards sustainability.

This special resource, so desperately needed today, is not only to be found among planning specialists (designers, engineers, architects, and urban planners); it is to be looked for among all the actors involved in the building of a city: from those who decide land-use policy, to those immersed in the "normality" of their everyday lives. Constructing the future and, especially today, the transition towards sustainability, is a social process in which everyone has a role to play, with varying powers and responsibilities.

In my opinion, this last observation makes our initial optimistic vision, which underlies our entire proposition, less naïve. Design activity that leads to sustainability is not a one-sided, individual project based on a single vision. Instead, it is a complex social learning process, a vast intertwining of initiatives in which we proceed through partial successes, errors, and unforeseen effects, and thus learn from experience. This learning process is also the result of the diffuse design

activity we are addressing here. The better orientated this capacity is, the more effective will be the resultant process, and the quicker and less painful will be the pathway towards sustainability.

URBAN FORMS AND FIELDS OF POSSIBILITIES

Let us move on to the focus of our interest, urban daily life. This entails the way in which daily functions appear to the inhabitants of a given city and emerges from a combination of factors. Among these, the most important are those associated with the *forms of the city*, especially its *density*, the *distribution* of its *functions*, the quality of its *infrastructure networks* (energy, water, transport, waste disposal), the *degree of connectivity* it offers its citizens (the capillarity and extension of its communication channels), the *services* it provides (the nature, quantity, and quality of services accessible at the local level), and also its *building traditions* (the principal types of building, construction systems, and technical systems in the buildings).

To these physical and territorial factors we must add others that constitute what we can call the *social forms of the city*. By these we mean: the *size* and *role of nuclear families* (or, more generally, the group of people who share a home and deal with some of the functions of daily life as a unit), the nature of local *expectations of well-being* (the acceptable standards of quality that are socially recognized at that particular time and place), and, obviously, the distribution of wealth and knowledge, and the societal features and institutions that promulgate a widespread participatory democracy.

Such factors differ widely in character. They depend on a variety of complex social phenomena and on options taken by numerous individuals and groups of people in times

4

and places far distant from each other. As a result, from the perspective of a single citizen, they appear to be beyond the influence of individual action and choice. In many ways, this perception is correct: the physical and social form of a city is something that the individual citizen can accept, not accept, or even try to force, but which one person cannot change in the short term. This constitutes a *field of possibility* within a given context, by which we mean the system of restraints and possibilities that govern what a person can and cannot do, i.e., the framework within which one develops objectives, and the array of potential strategies for achieving them. Of course, this framework also applies to those attempting to enact *sustainable* modes of living, defining the limits within which people can direct their own behaviour and their own consumer choices.

UNSUSTAINABLE EVERYDAY LIFE

As it appears today, urban daily life carries an unsustainable environmental weight. Initially we can say that this is true of every existing city, and every city imaginable up to now. This bitter observation is the point of departure for any other consideration of the subject. However, in the social learning process now underway, not all cities, not all urban forms, are to be found at the same distance from the finish line. They are not all moving down the same track; some are demonstrating transformation dynamics that, to all intents and purposes, look negative, while others are experimenting with activities and policies that appear promising.

For example, cities with low population densities are intrinsically worse off than those with medium or high densities. It is a considerable task to address the differing demands

for mobility induced by each, let alone the technical, economic, and environmental efficiencies of different service ideas. Contrary to cliché and the pseudo-ecological stereotypes in circulation, on the whole, it is easier to think of sustainable solutions in compact cities than in areas of thinner urbanization. Given this, it is a provocative notion to think that Hong Kong might be a better starting point for sustainability than Los Angeles.

The existence of certain infrastructures (discrete garbage/recycling collection, gas supply networks, and water and sewage networks) can make "virtuous" behaviour by citizens practical in ways that would otherwise be impossible, even with the best of intentions. For example, it would be useless to separate rubbish in the absence of a wider system able to process recyclables. Similarly, the existence of commercial activities and decentralized services tends to give vitality to a neighbourhood, a vitality which is eroded when these activities are concentrated in large suburban shopping malls.

Per-capita consumption is heavily affected by the small average size of households. On average, a person living alone consumes more than twice the amount he or she would consume if living in a nuclear family of four. The size of the nuclear family influences the allocation of furnished, heated, and air-conditioned domestic space and influences the conservation and preparation of food, which is particularly important.

In conclusion, it is evident that socially recognized standards of well-being (which are not easily modified), strongly influence the general profile of consumption. For example, expectations for winter heating and summer air-conditioning are the result of a complex socio-cultural process. The consequences can be paradoxical, and dramatically negative in environmental terms: consider the polar temperatures maintained in public buildings and shopping malls in many tropical cities and the tropical temperatures evident in those of winter cities.

EZIO MANZINI

Similar reflections can be made on many other issues in which a misunderstood idea of well-being has led to a truly absurd, not to say tragic, situation. Consider the growing distortions in diet that have made obesity one of the main health and social concerns in most economically developed countries, while other parts of the world are suffering from a lack of food. Further, the development of food systems that support these distortions are dramatically and self-evidently unsustainable.

SUSTAINABLE EVERYDAY LIFE?

In the light of these examples, it seems evident that the unsustainability of everyday life in present-day cities is, historically, the result of complex social processes and political and economic decisions. Today, such processes and decisions are being systemically consolidated and are not easily changed by individual daily actions. All this would lead us to think that anything that can be done on an everyday scale and starting from "the bottom" would have little margin for freedom and little chance of being effective, given the problems we are facing.

This impression is both true and false. It is true to the extent that individual behaviour and consumption decisions cannot in themselves modify the physical and social forms of the city. It is false because the transformation of complex systems can be instigated by the stress of many individual activities. Cumulatively, these exert pressure from within, each on a "micro" scale, and can set the conditions for a "macro" scale change. Individual citizens and their communities can engage in such actions and, fortunately, many are already doing so.

Looking carefully at the social dynamics of the city, we realize that something is

happening. The limits created by previous decisions can be challenged. What exists already can be re-invented, with a view to new uses, and technology and current organizational skills can create new opportunities. All of this can generate the cultural and operational conditions for totally new – perhaps unimagined – solutions and sustainable ways of living.

This "something happening" emerges from a combination of research studies, projects, and concrete activities. These indicate promising and practical pathways because they break with dominant ideas and consolidated habits in ways that are consistent with sustainability guidelines. Practical, because these pathways are supported by social dynamics and technological trends that are already in progress and, if steered in the right direction, may facilitate their realization.

To understand this better we need to carefully observe how the relationships are defined between urban spaces, systems of products, services and infrastructures, and the overall quality of the context we live in. More generally, we need to understand how people act within this framework while pursuing their desired conditions of well-being.

SUBJECT-ACTOR AND CO-PRODUCTION OF VALUE

In order to talk about how people search for well-being we must first describe the protagonist of our story. To be more specific, since we are particularly interested in the relationship between this person and the system of artefacts that contribute to an idea of well-being, we shall refer to this person as the *subject-actor,* who is considered within a given context and who adopts an action strategy to achieve a particular result.

This picture of the subject-actor, placed in context, is what distances our proposition

from the more common notion of *subject-consumer*, who is usually considered as a figure isolated from the complexity of a specific living context and reduced to a single role, i.e., that of consumer.

The subject-actor model, on the other hand, offers the possibility of considering a protagonist who participates in the process of value production, in other words, one who actively contributes to the achievement of an outcome. The focus on the potentially engaged role of the subject is fundamental if we want to move away from a picture of product-based well-being and its corollary, a subject limited to the role of consumer.

To achieve a desired result, the subject can contribute through various *forms of participation*. These will be determined by *personal resources*, physical, economic, and cultural (i.e., the subject's knowledge, skills, and physical and economic capability). Participation will also be influenced by the *time* the subject can and wants to dedicate, and his or her capacity for concentrated *attention*.

The combination of these variables gives rise to various *action strategies*, which, for simplicity's sake, can be collated on a *passive versus active* scale. At one end, the subject is considered as one to be served, and at the other, as a player with potentially valuable resources.

DISABLING AND ENABLING SOLUTIONS[2]

"If someone is hungry do not give them fish. Give them a fishing rod and teach them how to fish." This ancient wisdom reinforces the idea that active engagement is critical and that the pursuit of comfort and economic growth, when based on passive consumerism, is unsustainable.

In the last century the dominant idea, generated and propagated by the West, was: *"If someone is hungry give them fast food or a tin of ready-to-eat (or, if they can afford it, give*

9

them a meal in a luxury restaurant)." Whatever you do, give them something that requires of them no effort, no thought, no knowledge of food preparation, but something that boosts the economic activities associated with food production and service. To be more precise, give them something that leads to a reduction in the informal economies of self-production and non-monetary exchange and an increase in the formal economy where, to meet a demand for food, there are other entities (private enterprise or public networks) that produce and deliver the services and products necessary.

The case of food is obviously emblematic of a far wider tendency that affects every aspect of our daily lives: from healthcare to our children's education, from the maintenance of our possessions to that of the homes and the places in which we live, from the basic ability to entertain ourselves and be on our own without getting bored, to that of socializing. In this way, healthcare requires doc-

tors, hospitals, and medicine, and children's education requires schools, gyms, televisions, and electronic gadgetry. Moreover, the up-keep of material goods is replaced by disposable products and the need for public space is replaced by visits to private sector shopping malls or theme parks. Our capacity to entertain ourselves and to socialize is now swept away by an onslaught of prepackaged entertainment media, from TV and video to the Internet. And all this, so it is said, turns the wheels of the economy and produces wealth *... for everybody.*

This way of seeing things began in the late 1800s and for almost a century there was no strong rival view. This notion of economic development was even absorbed into the ideology and practices of the communist regimes. Today, prevailing neo-liberalism has transformed this model into a quasi-religion where consumption is promoted as a moral obligation. In Italy, for example, a public television advertisement was broadcast over

and over again showing a gentleman, carrying shopping bags, who was thanked warmly by all who crossed his path, simply because he had bought things. The message of the story lies in the contribution he has made to society through his shopping. Little does it matter what is actually in the bags!

Now, however, perceptions are changing. Even though this model for well-being is still pervasive, it no longer holds the same ability to convince. Above all, its predominance no longer goes unchallenged; today, other ideas and other models are circulating.

THE TRADITIONAL IDEA OF COMFORT AND ITS CRISIS

New ideas, new experiences, and new opportunities are emerging. To understand the nature and causality of these nascent phenomena, however, we must recognize the crisis precipitated by our previous unsustainable ideas and practices. Therefore, I shall briefly discuss its environmental, social, and psychological dimensions.

The most evident, and somehow irrefutable, crisis is environmental: beyond a certain threshold, our conventional way of conceiving well-being, and the economy that supports it, produces disaster. Today, 20 per cent of the world's population (living more or less according to this model of well-being) consumes 80 per cent of the available physical resources. If nothing changes, the remaining 80 per cent of the world's population, to whom we are trying to sell the same dream, will have to make do with the remaining 20 per cent of these resources, thereby severely exacerbating the environmental disaster and with little hope of attaining the promised dream. In other words, the notion of well-being based on consumption is founded on a promise that we now recognize is impossible to keep. Hence the defensive stance of the

11

rich Northern world, unwilling to change its lifestyle; the aggressiveness and frustration of the East and South, caught between attempts to make their own place, and the frustration of realizing that, no matter how you divide things, there are simply not enough resources to allow everybody to enjoy the dream (as advertised so well on TV). Hence the commercial aggressiveness on one side, and the social and political disaster on the other that, unfortunately, we see growing every day; conflict, wars, and terrorism sprout and prosper in the fertile ground of this widespread frustration.

Now let's move on to the social dimension. Some time ago, I read in a newspaper that elementary cooking courses had been set up in Japan for retired single people. These people, after a life of work, realized that they did not know how to achieve the most basic tasks of domestic life. In addition, there was no possibility of them accessing compensatory support services that such an inability made necessary. I don't know if this story is true. Even if it is not, however, it is very true to life. To give another example, in the past few years in Italy, at every flu outbreak, hospitals have been flooded with patients and the entire system goes into a state of crisis. Is this because today's flu is worse than the strains of yesteryear? No, it is just that increasingly people find themselves either alone and unable to cope, or family and friends are unable or unwilling to provide the necessary care.

The question we must ask is: can we really consider a society sustainable if every need, even the most basic and mundane, is met by a costly, complex system of products and services? Can such a welfare model continue to function where the user is merely the bearer of problems and services must always provide a complete solution? The idea that the user, by definition, is only a bearer of problems to be solved may even have seemed practical as long as the service users were few, and the young, vigorous population, able to produce

the wealth necessary to fuel such services, was large. Nowadays, with the demographic pyramid turned upside down and the elderly outnumbering the young, this vision of social services can no longer hold.

To go beyond such models of well-being requires a thorough understanding of the reasons for their existence. Here I will merely observe that they came into being alongside the expansion in the mass production of consumer goods and, in particular, with the enthusiastic discovery that artefacts could be created and made to work for us like modern mechanized slaves. From this, and with the memory of the hardships associated with pre-mechanized daily life, came the idea of *comfort as the minimization of personal involvement*; i.e., when faced with a goal to achieve, the best strategy is *always* the one that requires the least physical effort, attention, and time, and consequently, the minimal amount of ability and skill to apply. The success of this idea is self-evident. Who, if in

a position to do so, would not try to reduce the burden, time, and psychological stress in dealing with the heavy or irritating tasks of daily life? Such a question has become merely rhetorical but the consequences are now being recognized as disastrous. Moreover, this has effectively produced a system where people are passive consumers of products and services, i.e., it is a *disabling solution*.

Fortunately, however, human nature is not so simple. The legitimate desire to avoid the hardships of pre-industrial life together with the boring repetitiveness of many daily tasks, is not an all-inclusive aspiration that can be applied in the same way to everybody and for every activity. Human beings may lean towards laziness and passivity, they may legitimately draw pleasure from being served, but they can also adopt the opposite attitude. They can find satisfaction, even enthusiasm, in doing a job well. They can rationally weigh up *action strategies* to determine which is the most effective and discover that, indeed, it

13

is worth doing certain things for oneself because, this can allow for the most economical solutions and offer freedom through self-reliance.

Of course, even a potentially active and participatory approach should not be considered as the only way forward nor as the only one that is ethically acceptable (as demanded by the value-of-work rhetoric of certain regimes). Human nature is contradictory. It offers the possibility of operating according to varying rationales and differing aspirations. This is its richness.

DESIGN AND ENABLING SYSTEMS

While acknowledging these contradictions and recognizing diverse ways of being and doing, we should look critically at the dominant homogeneous system of production, its way of offering products and services, and the idea of comfort that underpins it. This system has progressively led us to relinquish formerly widespread knowledge and skills, which have been absorbed into technical machinery and organizational systems. In turn, this has virtually eradicated those skills, abilities, and know-how that have historically enabled individuals and communities to deal with the most diverse aspects of daily life. We must now discuss whether and how it is possible to change direction, or if it is possible to imagine a system able to incorporate the active side of people and their capabilities in terms of sensibility, competence, and enterprise along with those benefits offered by technology, as noted above.

Effectively, focusing on what interests us most here, we must place a new idea of service alongside the currently dominant one of *services* as *disabling systems*.

Today the most widely held idea is one in which a service is designed on the assumption

that users are only passive bearers of problems. The new idea of service must start with an appreciation of the user's knowledge, abilities and motivations. It must be conceived as an *enabling solution*. The service must match the user's desired result and offer the means by which to achieve this result using his or her own capabilities to the best advantage. Properly designed, such a service could encourage participation by being perceived as a delightful, stimulating, and rewarding activity.

All this obviously has much to do with design, which, as a professional activity, became established in the early years of the twentieth century with the advent of mass production. Its ethical DNA was formed on an idea of *democracy of comfort,* and thus it has contributed to the production of *disabling* solutions.

However, in design, there has also been a strong idea that its role should be one of *improving the quality of life*; to act as a bridge between technical and social innovation and to propose artefacts that help people to live better. Yet today, the idea of "living better" needs to be radically redefined. And a design profession that does not wish to abdicate its most profound reason for existing must also be redefined along with its conceptual and operative tools.

A SOCIAL LEARNING PROCESS

So what we must do is change direction. We must focus our design energies and technological potential in ways that enable individuals and communities to live and work together, in ways that are more self-reliant and less passive, and in ways that consume far less of our environmental resources.

This option is, for the reasons expressed in the previous paragraphs, a necessity. However, what we would like to argue here is that it is also a concrete possibility. Of course, it

15

is not an inevitable destiny or a future that will develop by default. It is a possible future that could become real if we are capable of creating it. In fact, if the crisis of the disabling model can be described in its three dimensions – environmental, social, and psychological – the same can be done for the reasoning behind the new model of well-being emerging today.

The transition towards a sustainable society is a massive social learning process. The radical nature of the objective (learning to live better while leaving a light ecological footprint) requires vast experimentation, a vast capacity for listening, and an immense degree of flexibility in order to change when it becomes evident that a road taken proves to be a dead end. Sustainability and the conservation and regeneration of environmental and social capital means breaking with the currently dominant models of living, production, and consumption and experimenting with new ones. If this experimentation does not take place, if we are unable to learn from the new experiences thus generated, then the historical pattern of disabling solutions will continue.

A social learning process on this vast scale must involve everybody. This is, in itself, an overused notion. We are always saying: "Everyone must remember to switch off the lights when they leave the room and everybody must make the effort to put their rubbish in the right container...." Sure, but it doesn't stop there. In fact, this way of viewing participation, as small personal efforts in the upkeep of our own household or of our own planet, may in the long run prove misleading. What is required of everybody is not only incremental improvement on what the normal model of life proposes. As we have said, what is required is a change in the model – a radical change that, if it is to take place, does not require the acceptance of a new duty (the duty to make an effort for the good of the Earth and/or to help the poor). On the

16

contrary, it requires a drastic re-orientation of the idea of well-being. It requires us to go so far as to consider positive ways of being and doing, which in the current dominant model are seen as indifferent or negative. We need to rediscover the pleasure of moving on foot, of eating local fruit, of feeling the cycle of the seasons, of caring for things and places, of chatting with neighbours, of taking an active part in the life of the neighbourhood, of gazing at the sunset, etc.

Is this change possible? It is possible to adopt a viewpoint where these ideas are lived, not as an obligation, but as a new, positive way of living and doing.

SOCIAL INNOVATION AND CREATIVE COMMUNITIES

Potentially the definition of radically new ways of being and doing can lead to major transformation. It requires the bringing into play of all the capabilities that an individual or community possesses if it is to come about: from technical-scientific knowledge to practical skills; from philosophical reflection to artistic experience; from deductive logic to individual and social creativity. Each of these fields requires exploration and each holds its own prerogatives and its own specific history, which deserve telling. However, here we shall limit ourselves to the last of the fields mentioned, that is, individual and social creativity, which hold the promise for new forms of social innovation.

The questions to be asked are: do cases of radical social innovation exist that are relevant to sustainability? If the answer is yes, what impact could they have?

To the first question, my reply would be affirmative. Observing society as a whole and in all its contradictions, we can see that alongside numerous and unfortunately extremely worrying tendencies, signals are also

17

emerging that indicate different and far more positive developments. Such signals, while still weak, are clearly indicating that other ways of being and doing are possible – signals that, to quote the slogan of many contemporary movements, demonstrate that "another world is under construction."

Looking at society carefully and selectively, we can identify people and communities who act outside the dominant thought and behaviour patterns: *creative communities* which, when faced with a goal, organize themselves to achieve what they want directly. Such groups re-organize the way they live in their homes (e.g., the co-housing movement) and their neighbourhood (bringing it to life, creating the conditions for children to go to school on foot, fostering mobility on foot or by bike). There are also communities that foster new participatory social services for the elderly and for parents (the young and the elderly living together and micro-nurseries managed by enterprising mothers) and

that set up new food networks with producers of organic items, enhancing the quality and typical characteristics of their products (as in the experience of Slow Food, solidarity purchasing, and fair trade groups). The list of promising cases is endless.[3]

What do these examples tell us? They indicate that, already today, it is possible to do things differently and consider one's own work, one's own time, and one's own system of social relationships in a different light. They tell us that the learning process towards environmental and social sustainability is beginning to build a body of experience and knowledge. They tell us that there is a potential inversion of the tendency towards the disabling processes of the past (sadly still dominant today): the cases we are talking about here are the result of the enterprise and ability of certain people – creative communities – who know how to think in a new way and put different forms of organization into action.

THE OPEN FUTURE OF THE CREATIVE COMMUNITIES

However interesting the promising cases and creative communities may be, they are as yet only a minority phenomenon. We can ask ourselves what possibility they may have of spreading – what chance they have to achieve the scale needed for sustainability. The future is open and this legitimate question obviously has no definite answer.

However, these cases are so widespread and numerous that they appear to be more than a fleeting phenomenon and represent the beginning of a new story. Sceptics will certainly point out the size discrepancy between, on the one hand, big business, big finance, and the great international military system, and, on the other, a solidarity purchasing group, a mutual help network, the adoption of a tree by a family, an association of senior citizens committed to fostering green neighbourhoods, and a group of children adventuring to school on foot. However, these phenomena, small and weak as they seem, could grow and prosper. Obviously, we cannot know if this will really happen, but we do know that their future depends on us.

What must we do then? The answer to this is twofold: first, we must facilitate the spread of each of the promising cases and make them more socially and environmentally accessible and effective; second, we must foster a favourable context in more general terms. A context in which it is more probable that new promising cases like these may appear and, having once appeared, may endure.

19

CREATIVE COMMUNITIES, ENABLING SOLUTIONS, AND THE DESIGNER'S ROLE

Creative communities have invented different ways of behaving and thinking within their own particular context. Looking at them more closely, we realize they emerge from very specific conditions and, above all, they are the result of the enterprise of very special people. These are people who have been able to think and act by breaking out of the cage of dominant thought and behaviour. Although this almost heroic aspect is the most fascinating side of these phenomena, it is also an objective limit to their diffusion and often also of their endurance: exceptional people are not so common and, above all, they are not eternal.

Therefore, to help these ways of doing things endure and spread, we must start with these examples, and the organizational mod-els on which they depend, but we must go further. We must propose products and services specifically conceived to increase their accessibility and growth. In other words, we must reduce the difficulties we meet when setting up a similar venture. In short, going back to the terminology introduced previously, we must imagine and enact *enabling solutions* that are specifically devised to facilitate the diffusion, and increase the efficiency, of these kinds of promising self-help organizations.

For example: the intention of a group of parents to start up a small, home-based children's nursery could be facilitated by an *enabling solution* that includes not only step-by-step procedures that set out what must be done to establish such an enterprise, but also a system that provides the necessary assurances as to the suitability of the parent organizer and the house intended for the nursery. In addition, it should include provisions for health and educational support to cover those needs that cannot be met by the

nursery itself. Similarly, a solidarity purchasing group could be supported by special software designed to manage shopping and guarantee relationships with producers; a co-op housing project could be facilitated by a system that puts potential participants in touch, helps find suitable buildings or building plots, and helps overcome any administrative and financial difficulties. The list of examples could be expanded.

On a case-by-case basis, enabling solutions can be generated that build on the capabilities of organizers and provide the necessary additional support to cover any areas of weakness, thus integrating knowledge and abilities that were previously absent.

A new, different, and fascinating role for the designer emerges from this. A role that does not substitute the traditional one, but that works alongside it, opening up new fields of activity not previously considered.

The first step is to take social innovation as a departure point and to use one's specific skills and abilities to explore and propose new directions for products and services. In practice, this involves moving in the opposite direction to that more typically taken by designers. Instead of starting with a technical innovation and then proposing products and services that apply this innovation, here we start with a social innovation and propose products and services to effectively enable its realization.

The second step designers must make is to consider themselves part of the community with whom they are collaborating – to be and act as experts participating, peer to peer, with the other members of the community in the generation of promising endeavors, and the evolution of these cases towards more efficient and accessible systems.

21

REFERENCES

EMUDE, Emerging User Demands for Sustainable Solutions, 6th Framework Programme (priority 3-NMP). European Community: internal document, 2004.

Florida, R. *The Rise of the Creative Class: and How it is Transforming Work, Leisure, Community and Everyday Life.* New York: Basic Books, 2002.

Jégou, F. *Food Delivery Solutions: Cases of Solution Oriented Partnership.* Edited by P. Joore. Bedfordshire, UK: Cranfield University, 2004.

Landry, C. *The Creative City: A Toolkit for Urban Innovators.* London: Earthscan, 2000.

Manzini, E., and L. Collina. *Solution Oriented Partnership: How to Design Industrialized.* Edited by E. Evans. Bedfordshire, UK: Cranfield University, 2004.

Manzini, E., and F. Jegou. *Sustainable Everyday: Scenarios of Urban Life.* Milan: Edizioni Ambiente, 2003.

Manzini E., and C. Vezzoli. *Product-Service Systems and Sustainability: Opportunities for Sustainable Solutions.* Paris: UNEP, 2002.

Mont, O. *Functional Thinking: The Role of Functional Sales and Product Service Systems for a Functional Based Society.* Research report for the Swedish EPA. Lund: IIIEE Lund University, 2002.

Moscovici, S. *Psycologie des minorités actives*, 1979.

Ray, P.H. and S.R. Anderson. *The Cultural Creative: How 50 Million People Are Changing the World.* New York: Three Rivers, 2000.

SUSTAINABLE DESIGN

Stuart Walker

Sustainable development is a widely used but often ill-understood term. It characterizes a type of development that simultaneously takes into consideration three key sets of issues – economic development, ethical and social concerns, and environmental stewardship. Over the last ten years, this term has entered the public consciousness and there is wide agreement, at least in the public realm, that the pursuit of sustainable development is necessary, desirable, and urgent. Despite this, progress is slow and there is little understanding of the sheer magnitude of change that is required. Significant progress towards sustainable development cannot be achieved by maintaining our current lifestyles in the economically developed countries, and perhaps making small, incremental adjustments; our lifestyles are far too consumptive and demanding of the Earth's resources and too imbalanced in terms of social equity and justice. Instead, new ways of living have to be conceived that are markedly different from those prevalent today, and these new ways have to be effectively envisioned and communicated. This is where the designer, and perhaps especially the interdisciplinary, environmental designer, can contribute. Moreover, while steps toward these new ways of living might also be small and incremental, over time, society can become transformed.

Design is a creative discipline, where students are taught to tackle problems by visualizing alternative possibilities and to develop and define those possibilities in various forms in order to communicate them to others. The problem-based, imaginative design process can be applied to all sorts of areas – from the design of human interventions in a landscape, to the design of urban spaces, to architecture, products, graphics, and so on. These are the traditional areas of specialization for the design disciplines. However, when we introduce the notion of sustainable development, the boundaries between these distinct disciplines can become barriers – barriers to change and

STUART WALKER

barriers to the imagination. These various branches of design, in their singularity, are as much a product of our unsustainable ways of living as anything else. The compartmentalization and specialization of our activities, a phenomenon that emerged only in modern times, hinders us in seeing beyond our particular areas of concern and prevents us from appreciating the relationship between our activities and their cumulative and often damaging effects. The separation of disciplines causes a *distancing from* consequences. For example, the designer of a running shoe or small appliance at a consultancy in California does not see the consequences of his or her design decisions when the product is manufactured in an exploitative sweatshop on the other side of the world.

If I might put it this way, to understand the real consequences of our actions, the effects must affect us. We must bring them home – so that they are immediate, recognizable, and attributable. This is one of the reasons why *localization* figures so highly in virtually all the prominent literature on sustainable development. We must make our activities local. In a connected world, of course, we can debate what the term *local* actually encompasses today, but I think the meaning is clear. Our activities have consequences, those consequences have effects – and we must become more fully aware, at an immediate visceral level, of those effects – in ways that touch us and not merely as abstract notions or at an intellectual level that we can easily set aside because they are occurring in someone else's backyard. When it comes to the planet, their backyard is our backyard, and when it comes to society, as Charles Dickens once had Marley's ghost say, "Business! ... Mankind was my business.... The dealings of my trade were but a drop of water in the comprehensive ocean of my business!"[4]

The environmental damage caused by the activities of those living in the world's

richest nations and the massive concentration of wealth in the hands of a few within those same nations represents an appallingly short-sighted, unethical, and unconscionable mistreatment of people and place. Sustainable development has been proposed as a way of ameliorating some of these problems. The task is immense and we cannot be naive – environmental destruction and the inequitable distribution of wealth will never be eliminated – but the levels of both have become so disturbing that a significant reassessment of our assumptions and our expectations is needed. In the field of product design, for example, this can take the form of reassessing the scales of manufacture so that more can be achieved at the local level which, in contemporary mass-production, is entirely absent. But there is more to be done – the very need for products, which demands resources and energy, and causes so much waste, has to be reassessed as a means of creating wealth. The profligate use of increasingly rare resources

for often trivial products cannot be sustained – either morally or environmentally. This is where the approach presented in this workshop comes into the picture. Here the focus is not on the design of things, but on the design of a scheme or system for enabling people at the local level to contribute to sustainable development through the more effective use of the resources they have at their disposal; its focus is the design of imaginative solutions that enable people to act.

The workshop looks at everyday tasks – people meeting to talk or learn, people needing to shop for food, people growing things in their garden, people living in a community. To achieve these simple everyday things in a more sustainable way is not difficult to imagine – we can all conjure a utopian vision of some idyll. What is much more difficult is to think of how we can begin achieving these things now, today, with the places, spaces, and systems that already exist. This is a more onerous task – but it is the reality of the task

STUART WALKER

before us and we have no other choice but to start from where we are.

Early twenty-first-century society, in North America, Europe, and elsewhere, has become distinctive by its reliance on products, perhaps especially products related to personal entertainment. We have become what some have called "digitally obese."[5] These products are major economic drivers – for example, the computer games market generates billions of dollars annually; add to this the recorded music industry, the movie and video industries, and the television and Internet industries and it becomes clear that, in the scope of thirty years, we have moved from an industrial economy to an entertainment economy.[6] Not only do these developments represent a highly lucrative means of wealth creation; they also represent a system that constantly demands tangible products to deliver the new forms of entertainment. Perhaps more worryingly, they also tend to exacerbate the increasing atomization of soci-

ety. Personal entertainment is just that – personal and individual. When we act as if we are autonomous individuals, we do not act as a community. We spend less time and make less effort to come together to tackle issues of common concern and we do less for the common good. Poor voter turnout for elections in the economically developed countries is but one indicator of the apathy pervading the world's wealthier nations. Therefore, in regard to tackling issues of sustainable development, providing the motivation is a significant challenge. And one way to help tackle the motivation question is, firstly, to provide a vision of a desirable and preferable alternative, and secondly, to provide an appropriate and effective means of making that alternative a reality. This was the challenge of the workshop presented here. The work, completed over a period of just four days by graduate students at the University of Calgary, does not constitute a feasible, readily implemented solution. But what it does

represent is an initial step along the road towards a different kind of design approach – an approach that breaks away from traditional product design and breaks down traditional disciplinary boundaries. The student participants were from an interdisciplinary faculty, but this was the first time they had come together to apply these kinds of techniques to generate locally specific, community-based, non-tangible design solutions. The outcomes are conceptual but inspiring, and they begin to indicate a direction that makes use of what already exists and which has the potential to enliven communities and motivate residents; the outcomes are imaginative, positive, and hopeful.

SIGNIFICANCE BEYOND
FUNCTIONAL SINGULARITY

Barry Wylant

INTRODUCTION

Today's media is pervasive: movies, television, magazines, billboards, music, radio, and the Internet have an inescapable presence within contemporary western society. Embedded within all these various media is a vast advertising and marketing presence that effectively pays for it all. In this atmosphere of the never-ending sales pitch, it can be tempting to view people merely as consumers, overlooking other characteristics and priorities in their lives.

Consider for a moment the view of an outside observer, someone objective and unaccustomed to consumer society. He or she may, in reviewing a media example like the SkyMall[7] (a mail-order catalogue available to passengers on some U.S. airlines), arrive at rather bizarre notions of what typical North Americans are like. A quick and unknowing perusal of this document might lead to the conclusion that we are obsessed with the complete removal of dust in our homes, the perfect ionization of the air we breathe, the ultimate provision of bodily comfort (through various heating pads, massagers, and pillows that support almost any posture in any place), the exquisite organization of our closets and the precise trimming of nasal hairs. SkyMall is fascinating for its inane focus on the highly specific functionality typical of its products. Such items are presented in a way that their usefulness is self-evident, and there is a seductive promise of being 'worry-free' in the way they address troublesome issues of daily life.

Yet the SkyMall catalogue is also indicative of the pervasive nature of consumerism. Here our capacity as individuals is presented in a highly constrained, compartmentalized fashion, in which trivial needs demand the acquisition of highly specialized products. Within this context, we are treated as consumers first, while other aspects of our lives as parents, community leaders, coaches for local sports teams, and volunteers at community events are overshadowed and secondary.

FUNCTIONAL SINGULARITY

This compartmentalization encourages us to view the significance of any given product in terms of functional singularity. This focus requires that the product, in its conception, is understood and defined only within this narrow context of end use. As consumers we are often willing recipients and focus on the potential lifestyle improvement this functional singularity provides. This precludes consideration of any wider context or significance for the product, such as the resources required for fabrication, shipping, and disposal when the object is no longer useful. Within this myopic milieu there is little room for reflection about the broader implications of product acquisition or how such product use impacts society, communities, and the health of the planet.

COMPLEXITY IN PRODUCT SIGNIFICANCE

In Krippendorf's discussion of product semantics, product meaning can be understood quite broadly, beyond that of intended function. For example, a knife can exceed its intended end use as a cutting tool and be used as a pry, a nail cleaner, a scraper, a screwdriver, etc. This leads to complexity in comprehending the meaning of a knife. Krippendorf argues that "Meaning is a cognitively constructed relationship. It selectively connects features of an object and features of its context into a coherent unity."[8] Meaning is constructed, as one imagines or anticipates using the object or when one actually uses it, because both require the user to cognitively place the knife into a use context, whether potential or real. Krippendorf notes that many contexts are possible and therefore many meanings are also possible; the extent

33

of these is up to the user and limited only by his or her imagination.

The danger of the singular understanding, as presented in marketing media, is that it can become so dominant that consideration of other product meanings is often ignored by consumers. Indeed, manufacturers typically wish to establish such dominance so that other, potentially market-limiting meanings are negated and one's "critical faculty" is effectively neutralized.[9] Complexity in use can expand notions of product meaning. Within a larger understanding, meaning is more inclusive and can represent things beyond the product, such as the resources and the values committed to its making and all of the potential end uses that the product affords, including its ultimate disposal.

Complexity and singularity in product meaning is also reflected in Heidegger's criticism of technology. Here technology is not just a *means to an end* or a question of high-tech versus low-tech. Rather, it refers to all manner of things that people make: everything from spatulas and automobiles to flashlights and computers. Heidegger's discussion centres on the essential nature of *technology* in a larger and more general sense. Potentially there is poetic richness in the existence of any item or piece of technology, something readily seen in the meanings associated with ceremonial artefacts. Heidegger notes that a danger inherent to technology lies in any limitations to such poetic richness, something he refers to as an "enframed view."[10] In this, technology, and the convenience it affords, so effectively defines the context of one's actions that it often negates a wider consideration of any other issues at play. Indeed, Heidegger argues that much of modern technology carries this risk.

The loss of poetic meaning might seem inconsequential, but it predicates a limitation in the consideration of oneself when using technology. Potentially the user becomes secondary to the technology. An obvious

example of this is seen in Chaplin's movie "Modern Times," where the pace of work for an assembly-line worker is governed more by the mechanical demands of the belt-drive than by any reasonable notion of human exertion. Here technology sets the pace and context for human activity, leaving the user in a largely unthinking position. A more subtle (and perhaps more devious) notion of this can be seen in the planning of suburbs. For many North American cities, suburban streets are laid out in bays and cul-de-sacs in a manner known as a spaghetti plan. Such planning gives priority to automobile use over other means of transportation. Indeed, if someone needed a litre of milk from the local store then walking or cycling would not typically be considered – the default decision would be to take the car. The spaghetti plan does not emphatically prevent one from walking or cycling, yet the physical form of the environment is so strongly geared towards automobile use that consideration of alternative transportation rarely occurs. In this way, such planning assumes and encourages a singular notion of street use and transportation.

BEYOND SINGULARITY

The wider perspective for product use and significance discussed by Krippendorf and Heidegger allows for product meanings that can carry both environmental and ethical significance. Consideration of a product beyond its functional singularity can further serve as a key foundation for the notion of sustainability, despite the perceived ease and convenience of such compartmentalized solutions. For instance, the spaghetti plan of the low-density suburb is designed specifically for automobile use. This means that people are rarely seen on the streets and there is often a muted sense of *community*. Compare this to higher density, mixed-use communities

35

where public spaces are often populated, busy, and vibrant. Such lively and animated public spaces in turn contribute to a sense of place where the urban context is rich and community life, well-being, and safety are enhanced.

There is a challenge, then, to find a way to surmount our attachment to *singular* but deprived '*ease*' so that we are better able to leverage the investment of resources that we put into our products and environments. The workshop presented here explores one way to rise to this challenge. Students were invited to investigate and explore services that could better utilize what might be termed 'suburban assets' – things such as cars, roads, houses, and yards that are typical of a city like Calgary. It represents an exercise in using the single function end-state of these as a departure point for design explorations and a reconsideration of the artefacts within our built environment. In this instance, the design exercise addresses the development and introduction of community-based services rather than the design of specific physical products. As such, it is a novel and innovative exercise in progressing our thinking beyond the functional singularity that is so prevalent today.

WORKSHOP THEME: ENVISIONING A CULTURE OF SUSTAINABILITY

Stuart Walker and Barry Wylant

In developed nations there is significant economic and cultural dependence on the consumption of products of all kinds. Considerable resources are committed to the manufacture, distribution, and use of these products, and this, unfortunately, results in a tremendous use of energy and the generation of extensive waste and pollution. This is a linear process of consumption that continually creates more things for the landfill. Such a pattern typically gives emphasis to individual benefit over societal and community enrichment. It causes major environmental degradation, and it fosters immense social disparities and divisions. Furthermore, it does not appear to make us any happier.

The dependence on consumption is culturally pervasive, in large part due to the addictive convenience it affords. The ramifications are often not explicit, and the pattern continues because perspective is difficult to achieve; within their daily routines people are quite detached from the cumulative con-sequences of mass consumption. Sustainability initiatives are seen as an effective way to temper the consequences of such dominant consumerism. They address socio-cultural issues, environmental stewardship, and economics to achieve ways of living that are truly beneficial and sustainable for all. Yet, given the convenience inherent to consumerism and, discouragingly, the overwhelming scale of the problem, how compelling is it to act on these initiatives?

We are thus faced with a challenge: to develop practices towards sustainability that are not viewed as a chore. Such practices must become habitual, locally appropriate, and tenable. Sustainable solutions are least successful when their implementation is imposed. Rather, participatory solutions should be encouraged within a practical approach to everyday life. If there is to be any hope of a sustainable future, the relationship between daily life and its broader implications must be clearly understood.

STUART WALKER AND BARRY WYLANT

Enabling Solutions uses such a view to provide sustainable options in a convincing manner. Operating at a local scale, design is used as a catalyst to help develop and enhance local capacity, using readily available resources. The approach is not dependent upon the implementation of some *utopian* model. Rather, it represents the achievement of an alternative view, exploiting those resources that already exist within local communities. In this sense it offers a realistic and flexible model for advancing sustainability. Its potential is based on individual and collective initiatives. Such initiatives can create a more socially cohesive and improved quality of life, while simultaneously reducing environmental impacts.

The role of the designer in this instance is novel. It is not dependent upon the skill set of one particular design discipline; rather, it represents the use of design skills and design thinking in a more general sense. Here, in imaginatively examining Calgary suburbs, one can arrive at the understanding of 'suburb' as a valuable and resource-laden system. The purpose of the design exercise is then to develop a means that *enables* community residents to recognize and access the resources within this system, and to do so in manner that makes a significant difference. The design outcome may or may not be tangible in the traditional sense of industrial design, architecture, or urban design. Rather, it could be a website, a virtual or physical toolkit, or some other system or facility that enables local residents to act (both individually and collectively) in an innovative and useful manner. Hence the understanding and application of design is broadened to engender other types of solutions that transcend discipline-specific conventions and definitions. The integrative and creative skills of the designer are still necessary, as are traditional visualization and communication skills. It becomes the designer's task to co-develop, with the community, new ideas and directions, and then to

39

visualize and communicate these ideas back to the various community stakeholders. This is essential if the solutions are to be accepted, implemented, and advanced.

Furthermore, *Enabling Solutions* allows individuals to see that their needs can be met in ways that do not necessarily require new *product* purchases. Ideally, if it were sufficiently compelling, individuals would choose a community-based service or service/product system to address their needs, thereby using fewer resources and enhancing community well-being. Fundamentally, the exercise is about doing more with less (or with what already exists).

Within this particular exercise graduate design students initially undertook an examination of Calgary suburbs. They recognized that suburbs have an abundance of resources in the form of wide, relatively little-used roads, many different types and sizes of vehicles, large, often little-used interior spaces, and large private yards. This

is typical of many North American suburbs where such resources are under-utilized, yet considerable investment has been made to create and support them. For example, on a daily basis, many people use local suburban roadways as part of their commute to work. Yet, apart from rush hours, these extensive road networks remain largely idle. Similar instances of infrequent or under-use can be seen in the facility provided by vehicles, large homes, and yards. The recognition that such resources were under-utilized served as the workshop's departure point. Students then had to investigate and analyze specific attributes inherent to these resources, which could creatively be used to provide potential benefit. For instance, expansive suburban bays and cul-de-sacs can be used occasionally for weekend street fairs and similar public gatherings. Given the carrying capacity of pickup trucks and SUVs, these could be more effectively used through car-sharing and coordinating trips to the supermarket

and in helping the elderly who might have limited mobility. Large backyards could be used for gardening initiatives that can bring the elderly and the young together. Little-used rooms in large suburban houses could work well for community-based learning initiatives. The enabling solutions approach required students to identify the key players within the community, such as potential users and local facilitators who could initiate programs that would enable community access to these capabilities. In effect, students constructed a use scenario, the parameters of which were defined by locally available, yet under-utilized resources, each with constituent attributes that could potentially benefit a particular user group or groups.

The main design challenge required students to develop the means by which users could access these facilities. The student groups had to consider the key players, their incentives for becoming involved, other resources they might need (people, time, materials, Internet, capital, etc.), and so on. This had to be something that would make the organization and implementation of some type of program easy and attractive for its users – in effect, to provide a truly *enabling solution*. To achieve this, students had to consider a variety of needs on the part of community members: what information might be required? Who would need it? How could this be delivered, distributed, or otherwise accessed? What other components to the solution might communities and users need to put into effect a specific enabling solution?

This workshop approach represents a systematic, yet creative, way to address individual needs in a sustainable manner. It provides design students with the tools to identify community-based resources, to comprehend their inherent potential benefits, to identify relevant local players, and to generate the means to achieve this potential through an *enabling solution*. The main lessons of the workshop can be found in an enhanced view

41

of one's community and in the identification of new opportunities and arenas for design and design thinking that are not necessarily discipline-specific. Such an exercise is significant in that it provides a powerful approach that can result in solutions that meet individual needs, yet contribute to the community, enhance quality of life, and mitigate environmental damage.

STUART WALKER AND BARRY WYLANT

WORKSHOP PROJECTS

Within the workshop, students were organized into four groups. Each was tasked with a design project to conceive of an *enabling solution* that addressed the unrealized resource potential evident in suburbs. Such resource potential was seen to lie in under-used cars, streets, yards and interior domestic space. Students were required to investigate the problem context and in turn create, as deliverables, graphics that, hypothetically, could be used as discussion pieces within targeted community groups. The students groups had to create graphics adhering to the following regime:

44

- *Poster:* students had to develop a poster that could succinctly communicate the role of the *enabling solution* and the resource it addressed.

- *Platform Matrix:* allowed students to examine the players potentially involved with the *enabling solution* and what their motivation might be in participating.

- *Interaction Storyboards:* allowed students to identify the tasks that would need to be undertaken, what specific solution elements would be required to undertake those tasks, and who or what organization might provide those solution elements.

- *System Organization Map:* allowed students to map out the relationships existing in the *enabling solution* between players, the intended setting, solution elements, and the providers of those elements.

45

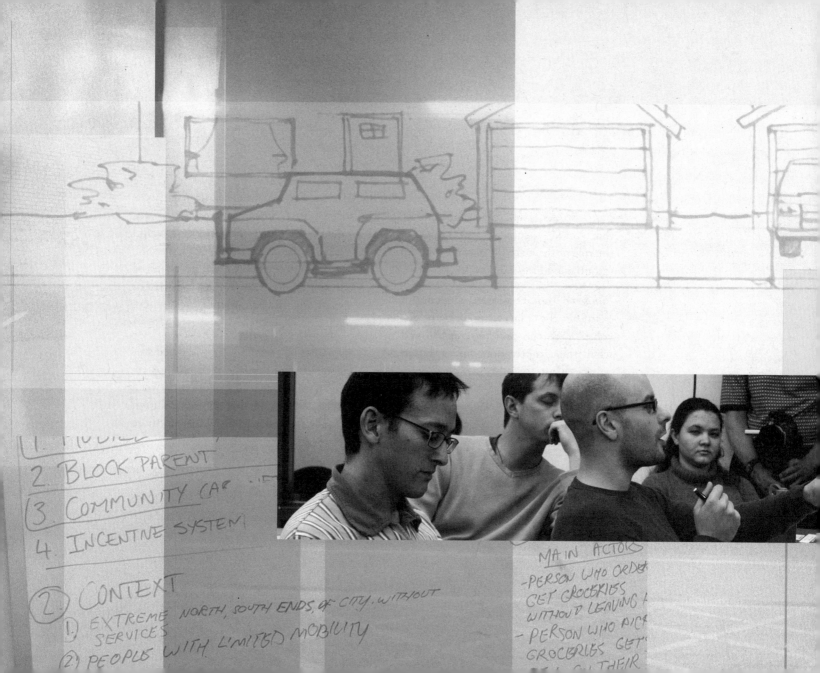

FLEX*M*OBILITY:
COMMUNITY CAR-SHARING AGENCY

HOW DO WE ENCOURAGE THE SHARING OF UNDER-UTILIZED, PRIVATE VEHICLES WHILE STRENGTHENING COMMUNITY TIES?

Team Members:
Cagla Dogan, Magnus Hanton, Darren Lee, Zhen Tian, Trevor van Gorp

47

CONTEXT AND PROBLEM

Many vehicles are used during the week for commuting to and from work. During a typical work day, many of these vehicles sit idly parked for the majority of the day.

48

Calgary has an affluent population with a large percentage of households owning at least one vehicle, thus there is an abundance of vehicles on Calgary roads and in downtown parking stalls.

49

Many households may buy a larger vehicle than needed for regular day-to-day activities. This allows for those occasions when large loads or several people need to be transported. Furthermore, households may purchase a second vehicle to meet additional transportation requirements.

Given the number of vehicles available, members of the community may wish to assist their neighbours or get help from their neighbours regarding transportation needs. However, some may hesitate due to a sense of obligation to "pay back" the favour.

POSTER

FlexMobility is a resource kit that facilitates the setup of a private vehicle-sharing network among interested members of a given community. This program is intended to be based in local community centres, providing a focal point for people to advertise, exchange numbers and contact information, and arrange for vehicle exchange times.

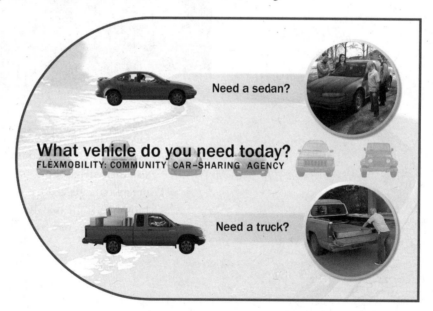

PLATFORM MATRIX

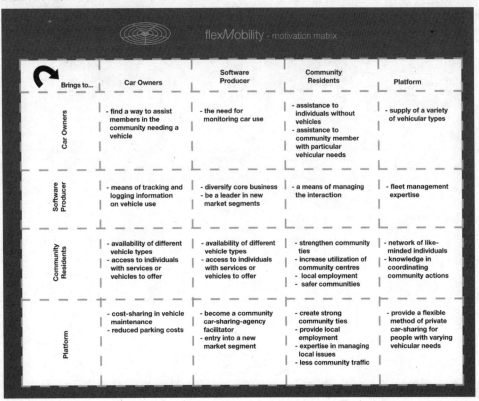

flexMobility - motivation matrix

Brings to...	Car Owners	Software Producer	Community Residents	Platform
Car Owners	- find a way to assist members in the community needing a vehicle	- the need for monitoring car use	- assistance to individuals without vehicles - assistance to community member with particular vehicular needs	- supply of a variety of vehicular types
Software Producer	- means of tracking and logging information on vehicle use	- diversify core business - be a leader in new market segments	- a means of managing the interaction	- fleet management expertise
Community Residents	- availability of different vehicle types - access to individuals with services or vehicles to offer	- availability of different vehicle types - access to individuals with services or vehicles to offer	- strengthen community ties - increase utilization of community centres - local employment - safer communities	- network of like-minded individuals - knowledge in coordinating community actions
Platform	- cost-sharing in vehicle maintenance - reduced parking costs	- become a community car-sharing-agency facilitator - entry into a new market segment	- create strong community ties - provide local employment - expertise in managing local issues - less community traffic	- provide a flexible method of private car-sharing for people with varying vehicular needs

53

INTERACTION STORYBOARD

flexMobility

service steps	Mike has lived in St. Andrews Community, Calgary, for 14 years. He wants to have his own small-scale business. He wants to use his work skills and help the community.	He does some research on community-based businesses and finds a software provider for a program to run a community car-sharing network.	He arranges a meeting at the community centre to introduce this initiative and to partner with the community association.	He learns how to set up the program and network.	He advertises through local media (newspaper, radio, Internet).
system actions		to provide a toolbox	to update files and documents related to the community	to provide training on the software program and user agreements	to support Mike in the generation of communication material
solution elements		Internet	file sharing		

54

INTERACTION STORYBOARD

flexMobility

service steps	Through notice boards and local radio, Tim learns about this initiative. He subscribes to the service via Internet to lend his truck for Tuesday afternoon.	Tina has recently rented a place in the community and learns about this service through the community website.	Using the database, Mike matches Tim's car up to Tina. Tina is notified by e-mail that a vehicle is available.	Tim drops the truck off at the community centre and is given a ride downtown on the courtesy shuttle. Tina takes the truck and brings it back after use.	Tim's truck is cleaned inside and out. Tim is brought back to the community centre by the shuttle, finding his truck in the same spot but cleaner.
system actions			to prepare the insurance and damage agreement for the vehicle	to facilitate the exchange of keys and provide courtesy shuttle service	to check and clean the vehicle
solution elements	media	Internet		vehicle swap	

SYSTEM ORGANIZATION MAP

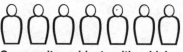

Community residents with vehicles
With/without unused vehicles

Community residents in need of vehicle access
With/without own vehicles

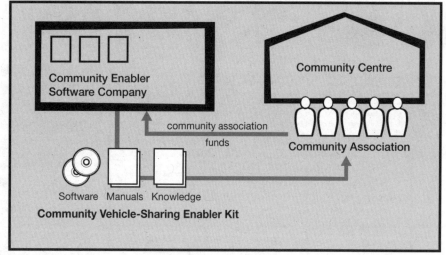

Community Enabler
Software Company

Community Centre

community association
funds

Community Association

Software Manuals Knowledge

Community Vehicle-Sharing Enabler Kit

Unused vehicles: especially big vehicles such as pickup trucks, sport utility vehicles, etc.

56

SYSTEM ORGANIZATION MAP

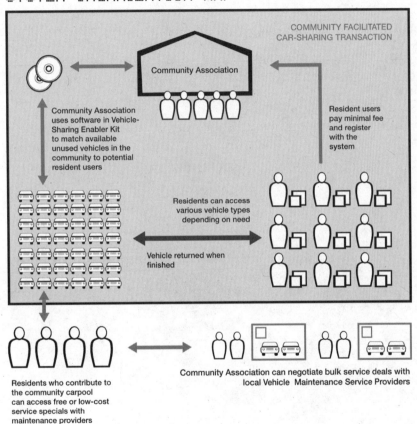

COMMUNITY FACILITATED
CAR-SHARING TRANSACTION

Community Association

Community Association
uses software in Vehicle-
Sharing Enabler Kit
to match available
unused vehicles in the
community to potential
resident users

Resident users
pay minimal fee
and register
with the
system

Residents can access
various vehicle types
depending on need

Vehicle returned when
finished

Residents who contribute to
the community carpool
can access free or low-cost
service specials with
maintenance providers

Community Association can negotiate bulk service deals with
local Vehicle Maintenance Service Providers

57

ALL THE STREET'S A STAGE:
MAKING A SCENE, REVITALIZING COMMUNITY

HOW DO WE MAKE A SUBURBAN STREET INTO A
MULTIFUNCTIONAL PIAZZA?

Team Members:
Ashwini Borkar, Henry Hama, Tara Murray, James Sloane, Qian Zuo

CONTEXT AND PROBLEM

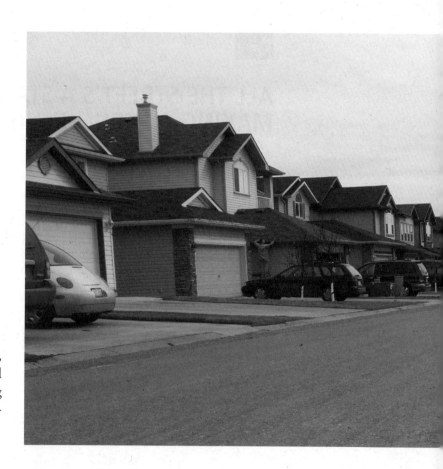

Suburbia is a place where people dwell, typically with a focus on one's family and household and with the objective of creating a sanctuary from work or the noise and congestion of the downtown core.

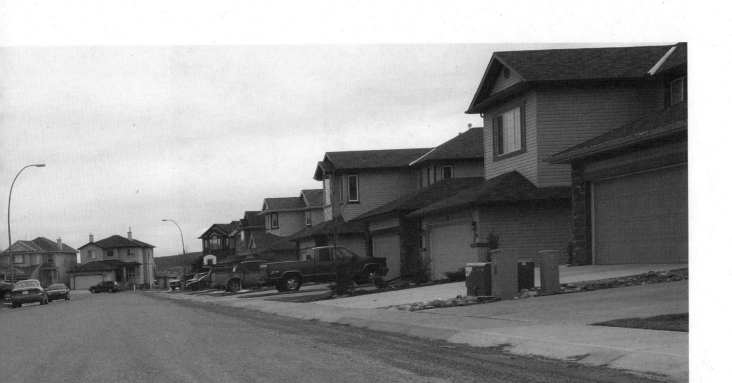

Workshop Projects

However, given the nuclear focus of suburban life today, streets are often empty and under-used while many residents may know very little about their neighbours or community affairs at large, even after living in the same area for years.

Public gatherings are seen as a means to benefit the community. They can break down the inward focus of a typical suburban household and encourage stronger social ties between community members.

63

Initiating and organizing events such as block parties, street festivals, garage sales, and street hockey tournaments for kids can bring people together. Such events can make better use of the (often) empty streetscape and add vibrancy to suburban life.

64

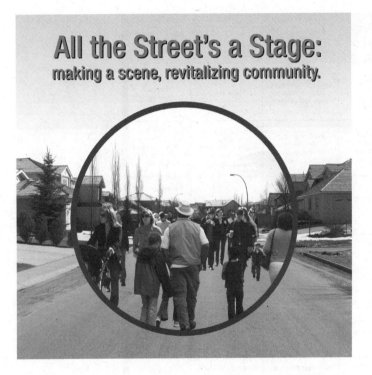

All the Street's a Stage:
making a scene, revitalizing community.

POSTER

The intention is to develop the means whereby community members can initiate and organize community events. Such events can animate the suburban streetscape and create a place where people interact with each other, where children can play together, and can foster a revitalizing presence in the community.

PLATFORM MOTIVATION MATRIX

Brings to...	COMMUNITY LEADER	COMMUNITY MEMBERS	COMMUNITY ASSOCIATION	WEB SERVICE	SOLUTION BUSINESS PARTNERS	PLATFORM
COMMUNITY LEADER	Self-satisfaction	Direction Leadership Ideas Someone to believe in	Direction Leadership Ideas Someone to believe in	Business networking Future business Goals and direction	Networking	Direction Ideation Planning Effort
COMMUNITY MEMBERS	Participation Feedback on what works within community	Support and safety to each other Networking	Participation Feedback Organizaiton Assistance	Provide greater numbers for business feedback on service	Provide greater numbers for business feedback on service Networking	Care Revitalization Usage Participation
COMMUNITY ASSOCIATION	Support Encouragement Enablers of plan	Leadership Organization Support Direction and ideas	Support and confirmation of good ideas Self-assessment	Feedback Organization Assistance	Feedback Enabling actors	Direction Planning Effort Time
WEB SERVICE	Complete service package Expertise Variety of fun events	Support and organization with community leaders Fun events	Complete service package Expertise Choice of fun events	Self-promotional material Happy clients	A network Simple client interaction Multiple jobs	Coordination Professional service Solution partners
SOLUTION BUSINESS PARTNERS	Professional services Opportunities for activities and equipment	Professional services Low community cost Appropriate market	Professional services Low community cost Aid to success of event	Partners Suppliers Fulfillers of the website mission	Affliation with other companies Chance to encourage activity	Professional services and products Action
PLATFORM	Effective space use Community ownership A happy community	Effective space use Community ownership A happy community	Effective space use Community ownership A happy community	Perfect place to run a business uitlizing existing infrastructure for a noble cause	Perfect place to run a business uitlizing existing infrastructure for a noble cause	Intrinsic opportunities for street usage and community revitalization

ENABLING SOLUTIONS FOR SUSTAINABLE LIVING

Pre-Condition Setting

| There was not a lot of activity in Bob's neighbourhood. As community association leader, Bob felt compelled to revitalize social interaction in the neighbourhood. | Bob knew that each community association received an information package from Street Event, a community revitalization group. | Bob finds the Street Event website and downloads all the information required to tailor his community event. It also allows him to schedule and organize vendors for this event. | The website allowed Bob to create promotional material to support his community event. | The website allowed Bob to order the Street Event kit that helps his community association to set up the event. It is delivered on the event day. |

67

Real-Time Enabling

| Bob gets help from community association members to set up and coordinate the event. | The solution partners arrive and set up their stalls and equipment at the community event. | The event runs the whole day in the community. The neighbourhood families come out to participate in the event activities. | After the day of activity, Bob and the community association clean up the leftover debris. The event makes enough money to host their next community event. | Street Event comes to pick up the remaining components of the event kit at the end of the day. | The event brings the community closer where new friendships and acquaintances are formed. |

SYSTEM ORGANIZATION MAP

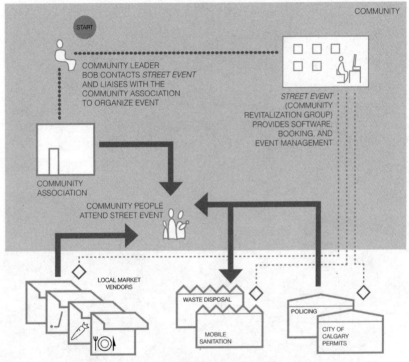

COMMUNITY

START

COMMUNITY LEADER
BOB CONTACTS *STREET EVENT*
AND LIAISES WITH THE
COMMUNITY ASSOCIATION
TO ORGANIZE EVENT

STREET EVENT
(COMMUNITY
REVITALIZATION GROUP)
PROVIDES SOFTWARE,
BOOKING, AND
EVENT MANAGEMENT

COMMUNITY
ASSOCIATION

COMMUNITY PEOPLE
ATTEND STREET EVENT

LOCAL MARKET
VENDORS

WASTE DISPOSAL

MOBILE
SANITATION

POLICING

CITY OF
CALGARY
PERMITS

SOLUTION PARTNERS
PROVIDE ALL NEEDED LOGISTICS/SERVICES/SUPPLIES -
COORDINATED THROUGH
STREET EVENT

69

seed ⟶ seedling
exchange
 └ windowsills
 └ public facilities
composting

CALGARY GARDEN CONNECTIONS:
PEOPLE GROWING PEOPLE

WHAT CAN BE DONE TO MAKE BETTER USE OF UNDER-
UTILIZED OUTDOOR SPACE WHILE STRENGTHENING SOCIAL
TIES AND FACILITATING A SENSE OF STEWARDSHIP FOR
BOTH THE LAND AND ONE'S COMMUNITY?

Team Members:
Diana Aguirre-Delgado, Lisette Burga Ghersi, Bruce Fitz-Earle, Quentin Mattie, Joel Tobman

CONTEXT AND PROBLEM

As a city, Calgary dates from a time when many of its residents were early European settlers. For these people, land in their home countries was scarce or very expensive. On the Canadian prairie, land was offered by the government in exchange for development. The frontier attitude engendered by such homesteading and the open spaces afforded by the landscape can be seen to influence the characteristic urban (or, more accurately, suburban) sprawl of Calgary.

ENABLING SOLUTIONS FOR SUSTAINABLE LIVING

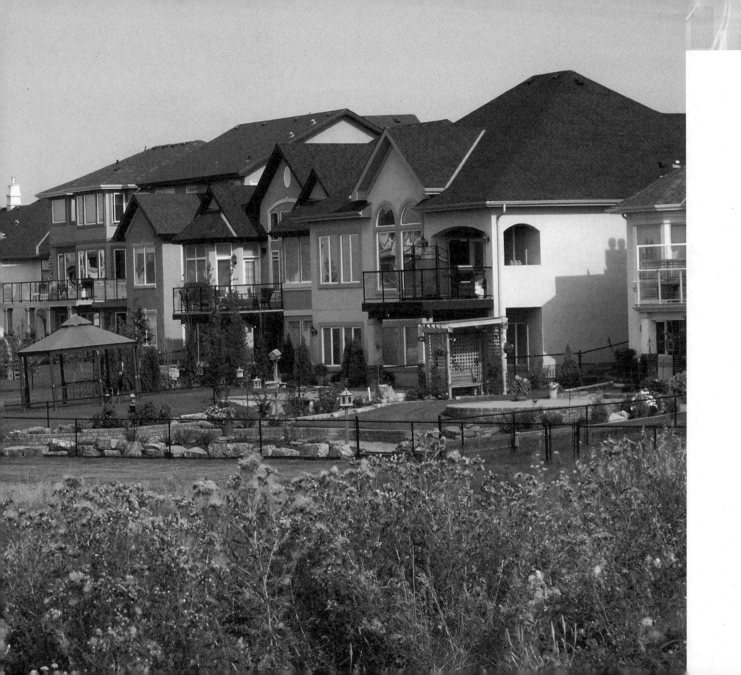

Many people throughout the city have larger lot sizes or yards for their homes than they are able (or desire) to take care of. In addition, there are many city and business-owned properties that sit idle and could be better utilized.

Recognizing the responsibility inherent in humanity's interaction with nature and our use of the land, there is an opportunity with these idle tracts of land for alternative uses such as gardening, which can both draw upon and enhance community resources.

ENABLING SOLUTIONS FOR SUSTAINABLE LIVING

Organic gardening would be strongly pro-
moted, with a special emphasis placed on
composting, thus reducing the amount of
biomass entering landfill sites. Even existing
structures and infrastructure could be uti-
lized to maximize their gardening potential.

Fresh Orchard Fruit

BC
AMBROSIA
APPLES
$1 69/lb

CANTALOUPE
$3.00 EA
Imported Product

Cherry pit

ATAULFO
MANGOS
$2.00 EA
Imported Product

Cherry pit

GRANNY SMITH
APPLES
$1 69/lb
Product of USA

79

Health
The Calgary Garden Connections (CGC) would contribute to and foster healthy, active lifestyles by facilitating access to organic gardening, in turn promoting the consumption of nutritious foodstuffs that such gardens produce.

ENABLING SOLUTIONS FOR SUSTAINABLE LIVING

Social Issues
The CGC program would also promote self-reliance and self-confidence and enhance links between Calgary's diverse demographic populations.

Knowledge
Traditional knowledge such as preserving (canning) and cold-weather gardening can be passed down through both informal (spontaneous) and formal opportunities (workshops). Workshops can also provide opportunities for people of diverse culture backgrounds to share knowledge with each other.

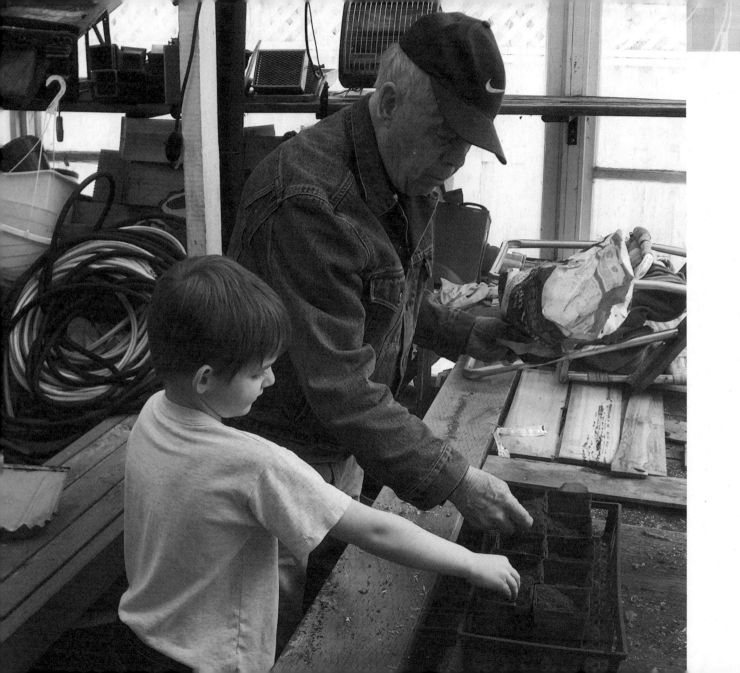

POSTER

Calgary Garden Connections proposes a system to utilize land 'wasted' in Calgary's suburban sprawl by providing a network to link homeowners (with idle property) to those who desire the chance to garden, yet lack the means to do so, such as renters and apartment or condominium dwellers.

people growing people

84

INTERACTION STORYBOARD

SERVICE STEPS	Alice has been feeling a bit isolated in her big house since her husband died. She used to have a wonderful garden, but her arthritis prevents her from doing as much as she used to.	Since moving to Calgary last year, Bob has missed the garden he used to have. His new apartment does not have anywhere for him to plant vegetables.	Both Alice and Bob sign up for Calgary Garden Connections online.	Calgary Garden Connections partners Bob with Alice so that Bob can use Alice's yard space for growing vegetables.
SYSTEM ACTIONS			To provide a website with information on the program.	Screening and partnering of landowners and gardeners.
SOLUTION ELEMENTS				Set up meetings between potential partners through events, workshops and seminars.

85

INTERACTION STORYBOARD

SERVICE STEPS	Bob plants and tends to the garden through the spring and summer. Alice helps with less labour-intensive aspects, such as watering.	When the vegetables are ready, Bob and Alice share the harvest.	Bob and Alice also sell some of their harvest at one of the Calgary Connections community markets, happily returning a small percentage of their sales to the network.
SYSTEM ACTIONS	Provide seeds, information and workshops for both Bob and Alice to use.		Organize and facilitate markets in communities throughout Calgary.
SOLUTION ELEMENTS	Seed bank, website with message board, information on gardening and events and workshops.		Organize and facilitate markets in communities throughout Calgary.

86

ENABLING SOLUTIONS FOR SUSTAINABLE LIVING

SYSTEM ORGANIZATION MAP

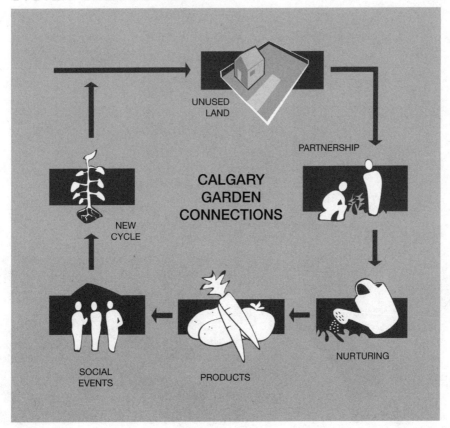

UNUSED
LAND

PARTNERSHIP

CALGARY
GARDEN
CONNECTIONS

NEW
CYCLE

NURTURING

SOCIAL
EVENTS

PRODUCTS

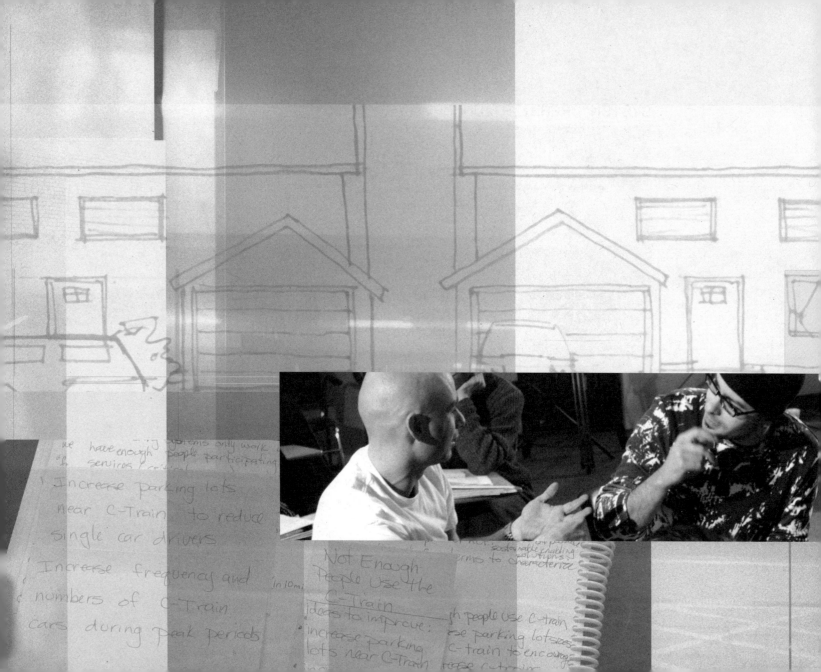

we have enough systems only work
services when enough people participating

Increase Parking lots
near C-Train to reduce
single car drivers

Increase frequency and
numbers of C-Train
cars during peak periods

Not Enough
People use the
C-Train

Ideas to improve:

Increase parking
lots near C-Train

MY CLASSROOM:
HOME-BASED COMMUNITY LEARNING CENTRES

HOW CAN WE USE ABUNDANT, UNDER-UTILIZED SPACE IN
LARGE, SINGLE-FAMILY HOMES TO IMPLEMENT A VARIETY
OF LOCALIZED, SEMI-PUBLIC FUNCTIONS AND ACTIVITIES?

Team Members:
Harald Albrecht, Khalil Jamal, Gillian Russell, Peggy Stirrett

CONTEXT AND PROBLEM

There is an abundance of under-utilized space in large single-family homes in Calgary. Furthermore, with continued suburban sprawl and expansive new communities, the time and resource costs required for travel to the nearest school (necessitating bussing) is significant and limiting.

90

Given the available space in large homes and a number of educated, stay-at-home parents, the potential resources necessary for schooling are readily available at the scale of the household and cul-de-sac (or suburban block). In pooling resources, the provision of home schooling can be shared across households, enhancing learning and facilitating socialization opportunities for students that can be lacking in individual home schooling endeavours.

91

CONTEXT AND PROBLEM

In providing community members with a coordinating network, My Classroom allows for improved quality and control of education. In localizing education at the level of the neighbourhood or cul-de-sac, it can reduce the need for transportation, time, and other resources. My Classroom can allow for insight, knowledge, and home-space resources to be shared across households involved in the network.

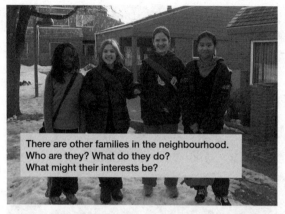

There are other families in the neighbourhood. Who are they? What do they do? What might their interests be?

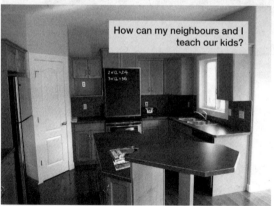

How can my neighbours and I teach our kids?

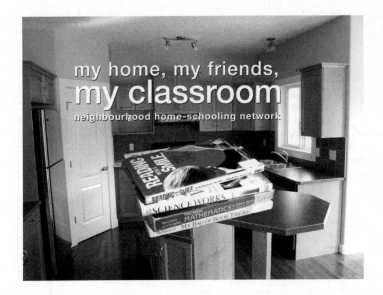

my home, my friends,
my classroom
neighbourhood home-schooling network

POSTER

My Classroom is a proposed coordination network that would allow parents to organize group home schooling within new or isolated suburban communities (which may lack local schools) and across households. As such, it would utilize unused space within the home, and through the coordination provided, enhance the learning experience. Small groups of parents could organize to provide home schooling to small groups of children, enhancing the shared learning experience and providing opportunities for socialization.

Furthermore, the network could also be used for the organization of other forms of local group learning (such as adult groups) or community activities.

93

PLATFORM MOTIVATION MATRIX

↻ Brings to...	Homeowner Educator	Kit Provider	Students	Parents and Teachers	Solution Partners
Homeowner Educator	A personal solution to work, life, and quality of child's education	A distribution channel for a business opportunity	Enhanced quality of education that is localized and personalized	An alternative to bussing or individual home-schooling	A new customer for products and services
Kit Provider	A single-source means of setting up and operating a shared home-schooling	A new business in an area of interest and chance to make a difference	A great educational experience	Assurance of enhanced quality of education (standards and certification)	Brand identity with community
Students	Focus of meaningful work	User input to product and service development	Socialization and learning from each other		User input to product and service development
Parents and Teachers	Shared learning and community	User input to ongoing product development	Shared knowledge	Shared learning and community	User input to ongoing product development
Solution Partners	Special purpose wholesale package of products and services	Single-source solution means	A great educational experience	Assurance of enhanced quality of education (standards and certification)	Better business opportunities and community relationships

ENABLING SOLUTIONS FOR SUSTAINABLE LIVING

Pre-conditions setting storyboard

service steps				
system actions	My family and I recently moved into our new spacious home in the suburbs. Our house is rather large and some areas are rarely used. I miss my family life, and I miss my old neighbours.	There are other families in the neighbourhood. Who are they? What do they do? What might their interests be?	My kids have to travel for two hours each day to get to school and back. The school we were promised is not there yet. What do my kids learn on the way to school? How many kids are in their classrooms?	Can I make a difference? How about using my extra space? How about teaching the neighbourhood kids? How about asking my neighbours to teach too? Could this help to pay the mortgage?
solution elements				

95

INTERACTION STORYBOARD

Pre-conditions setting storyboard

service steps				
system actions	I have to find out about home schooling. What are the requirements? Who can provide the know-how? What tools and equipment do I need?	There is somebody who can facilitate this and provide the solutions I need. They can help train me to manage this idea! By sharing this with my neighbours, we pool our resources. We have the same problems!	They told me how to home school and offered the know-how to set up my project. I need the program, the tools, and the equipment. I also need to know what other people are doing.	They helped me to understand what other people are doing through networking. Tomorrow, we start home schooling and our kids will learn together. We are sharing and building our community!
solution elements		To offer a kit of educational products and services enabling a user to set up a classroom in their home.	To support the home owner and the active parents of the students by providing teaching curricula and materials.	To allow the user access to educational networks.
solution elements	networks	@	equipment/ supplies	

SYSTEM ORGANIZATION MAP

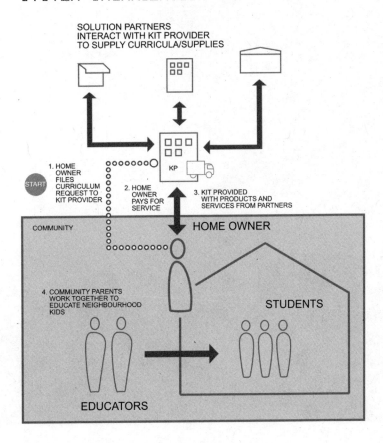

SOLUTION PARTNERS
INTERACT WITH KIT PROVIDER
TO SUPPLY CURRICULA/SUPPLIES

START

1. HOME OWNER FILES CURRICULUM REQUEST TO KIT PROVIDER

2. HOME OWNER PAYS FOR SERVICE

3. KIT PROVIDED WITH PRODUCTS AND SERVICES FROM PARTNERS

KP

COMMUNITY

HOME OWNER

4. COMMUNITY PARENTS WORK TOGETHER TO EDUCATE NEIGHBOURHOOD KIDS

STUDENTS

EDUCATORS

97

NOTES

NOTES

1 The viewpoint and methodology adopted are complementary to others that refer to an overall vision of a city, the planner's point of view, and the prevailing "top-down" methodology that these may adopt.

2 This part of the paper is based on the first results of an ongoing activity named Creative Community/EMUDE, Emerging Users Demands for Sustainable Solutions. It is a program (more precisely a Special Support Action) that is promoted as part of the 6th Framework Program (priority 3-NMP) of the European Commission and coordinated by INDACO, Politecnico di Milano. In the program ten research centres and universities and eight European schools of design are participating.

3 These promising cases emerge from the research done by the Faculty of Design and of the Department INDACO of the Politecnico di Milano, in collaboration with other European universities and research centres, and with the UNEP (United Nations Environmental Programme).

From this collaboration, some promising cases have emerged, which are described in E. Manzini and F. Jegou's *Sustainable Everyday: Scenarios of Urban Life* (Milan: Edizioni Ambiente, 2003).

4 Charles Dickens, *A Christmas Carol*, Stave One – Marley's Ghost (1843).

5 BBC News Online, *Britons growing 'digitally obese,'* http://news.bbc.co.uk/1/hi/technology/4079417.stm; accessed: 11/12/2004.

6 J. Gray, *Heresies: Against Progress and Other Illusions* (London: Granta Books, 2004) 159–66.

7 www.skymall.com; accessed July 2005.

8 Klaus Krippendorf, "On the Essential Contexts of Artifacts or on the Proposition that 'Design is Making Sense (of Things),'" in *The Idea of Design* (Cambridge, MA: MIT Press, 1995), 159.

9 Roger Scruton, *An Intelligent Person's Guide to Modern Culture* (South Bend, IN: St. Augustine's Press, 2000), 91.

10 Martin Heidegger, "The Question Concerning Technology," in *The Question Concerning Technology and Other Essays*, trans. William Lovitt (New York: Harper & Row, 1977).

sustainable, regenerative, enabling solutions.

Ezio Manzini

INDACO, Politecnico di Milano